Patterning Techniques

A pattern is a repetition of shapes and lines that can be simple or complex depending on your preference and the space you want to fill. Even complicated patterns start out very simple with either a line or a shape.

Repeating shapes (floating)

Shapes and lines are the basic building blocks of patterns. Here are some example shapes that we can easily turn into patterns:

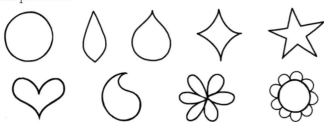

Before we turn these shapes into patterns, let's spruce them up a bit by outlining, double-stroking (going over a line more than once to make it thicker), and adding shapes to the inside and outside.

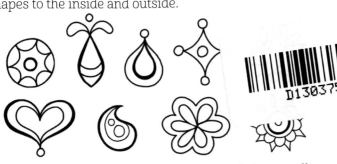

To create a pattern from these embellished shapes, all you have to do is repeat them, as shown below. You can also add small shapes in between the embellished shapes, as shown.

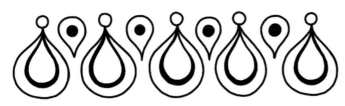

These are called "floating" patterns because they are not attached to a line (like the ones described in the next example). These floating patterns can be used to fill space anywhere and can be made big or small, short or long, to suit your needs.

Tip

Draw your patterns in pencil first, and then go over them with black or color. Or draw them with black ink and color them afterward. Or draw them in color right from the start. Experiment with all three ways and see which works best for you!

Tip

If you add shapes and patterns to these coloring pages using pens or markers, make sure the ink is completely dry before you color on top of them; otherwise, the ink may smear.

Repeating shapes (attached to a line)

Start with a line, and then draw simple repeating shapes along the line. Next, embellish each shape by outlining, double-stroking, and adding shapes to the inside and outside. Check out the example below.

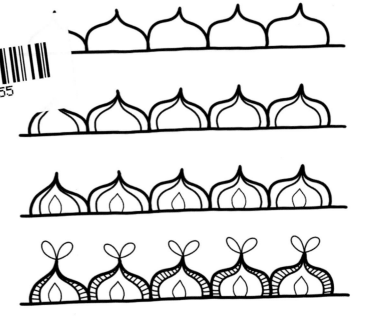

You can also draw shapes in between a pair of lines, like this:

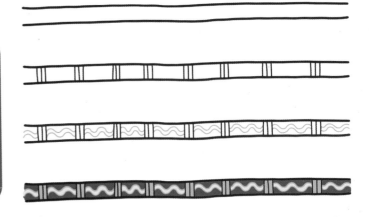

Embellishing a decorative line

You can also create patterns by starting off with a simple decorative line, such as a loopy line or a wavy line, and then adding more details. Here are some examples of decorative lines:

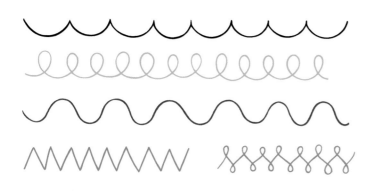

Next, embellish the line by outlining, double-stroking, and adding shapes above and below the line as shown here:

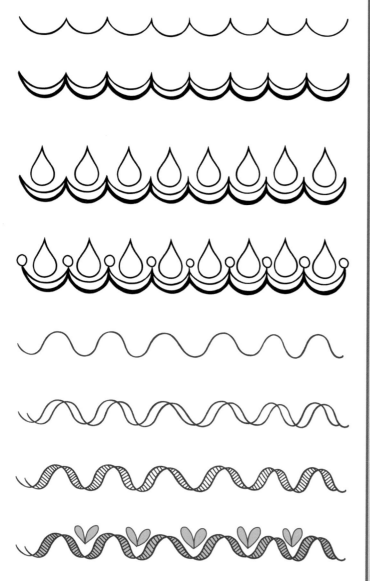

Color repetition

Patterns can also be made by repeating sets of colors. Create dynamic effects by alternating the colors of the shapes in a pattern so that the colors themselves form a pattern.

Tip

Patterns don't have to follow a straight line—they can curve, zigzag, loop, or go in any direction you want! You can draw patterns on curved lines, with the shapes following the flow of the line above or below.

These types of patterns look great when attached to the inner or outer edge of a drawing, such as the inside of a flower petal or butterfly wing.

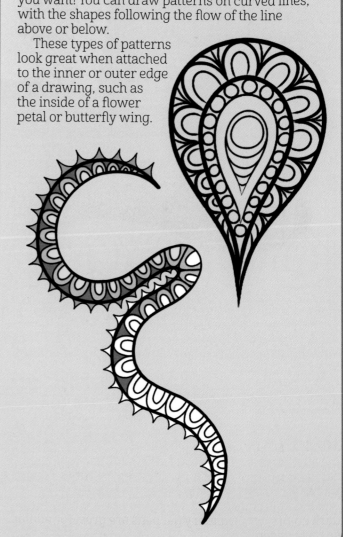

Coloring Techniques & Media

My favorite way to color is to combine a variety of media so I can benefit from the best that each has to offer. When experimenting with new combinations of media, I strongly recommend testing first by layering the colors and media on scrap paper to find out what works and what doesn't. It's a good idea to do all your testing in a sketchbook and label the colors/brands you used for future reference.

Markers & colored pencils

Smooth out areas colored with marker by going over them with colored pencils. Start by coloring lightly, and then apply more pressure if needed.

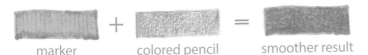

marker + colored pencil = smoother result

Test your colors on scrap paper first to make sure they match. You don't have to match the colors if you don't want to, though. See the cool effects you can achieve by layering a different color on top of the marker below.

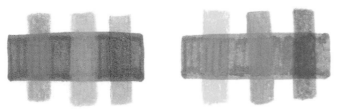

Markers (horizontal) overlapped with colored pencils (vertical).

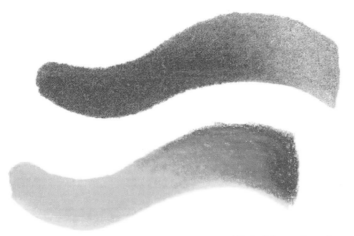

Purple marker overlapped with white and light blue colored pencils. Yellow marker overlapped with orange and red colored pencils.

Markers & gel pens

Markers and gel pens go hand in hand, because markers can fill large spaces quickly, while gel pens have fine points for adding fun details.

 White gel pens are especially fun for drawing over dark colors, while glittery gel pens are great for adding sparkly accents.

Shading

Shading is a great way to add depth and sophistication to a drawing. Even layering just one color on top of another color can be enough to indicate shading. And of course, you can combine different media to create shading.

Colored with markers; shading added to the inner corners of each petal with colored pencils to create a sense of overlapping.

Colored and shaded with colored pencils.

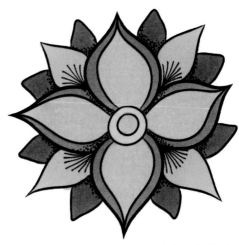

Lines and dots were added with black ink to indicate shading and then colored over with markers.

Color Theory

Check out this nifty color wheel. Each color is labeled with a P (primary), S (secondary), or T (tertiary). The **primary colors** are red, yellow, and blue. They are "primary" because they can't be created by mixing other colors. Mixing primary colors creates the **secondary colors** orange, green, and purple (violet). Mixing secondary colors creates the **tertiary colors** yellow-orange, yellow-green, blue-green, blue-purple, red-purple, and red-orange.

Working toward the center of the six large petals, you'll see three rows of lighter colors, called tints. A **tint** is a color plus white. Moving in from the tints, you'll see three rows of darker colors, called shades. A **shade** is a color plus black.

The colors on the top half of the color wheel are considered **warm** colors (red, yellow, orange), and the colors on the bottom half are called **cool** (green, blue, purple).

Colors opposite one another on the color wheel are called **complementary**, and colors that are next to each other are called **analogous**.

Look at the examples and note how each color combo affects the overall appearance and "feel" of the butterfly. For more inspiration, check out the colored examples on the following pages. Refer to the swatches at the bottom of the page to see the colors selected for each piece.

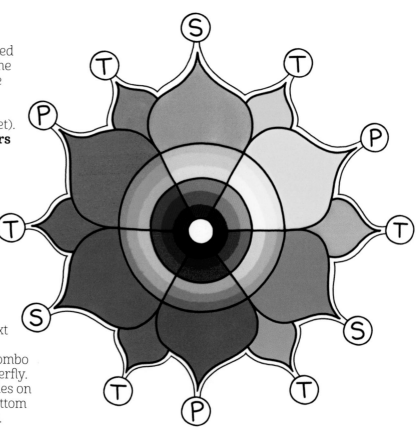

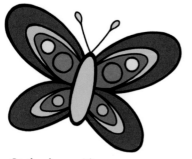

Warm colors

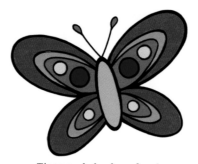

Cool colors

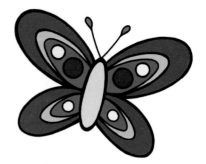

Warm colors with cool accents

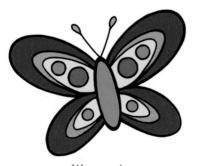

Cool colors with warm accents

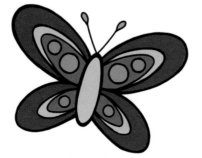

Tints and shades of red

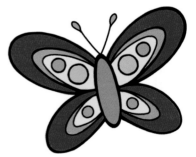

Tints and shades of blue

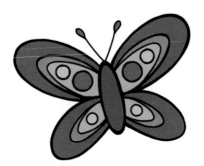

Analogous colors

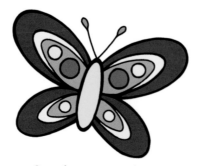

Complementary colors

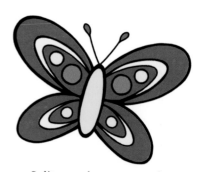

Split complementary colors

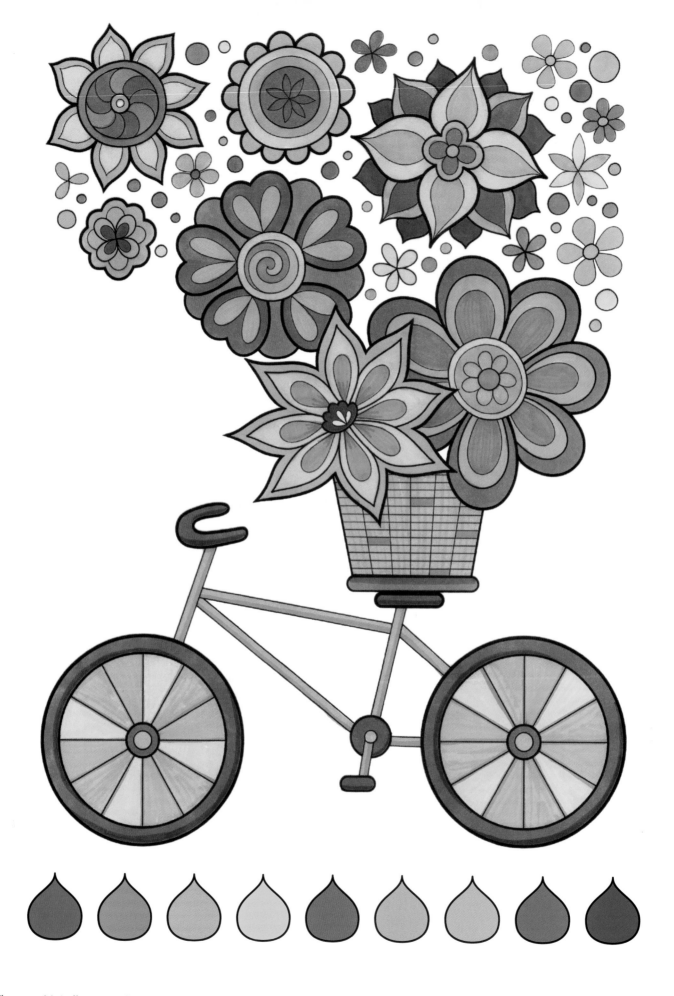

We're all golden sunflowers inside.

—Allen Ginsberg

Life is like a camera. Just focus on what's important, capture the good times, develop from the negatives, and if things don't turn out—take another shot.

—Unknown

All dreams spin out from the same web.

—Hopi saying

You don't need anybody to tell you who you are
or what you are. You are what you are!

—John Lennon

At the typewriter you find out who you are.

—Tom Robbins

Music can change the world
because it can change people.

—Bono

Don't worry about a thing,
'cause every little thing gonna be alright.

—Bob Marley, *Three Little Birds*

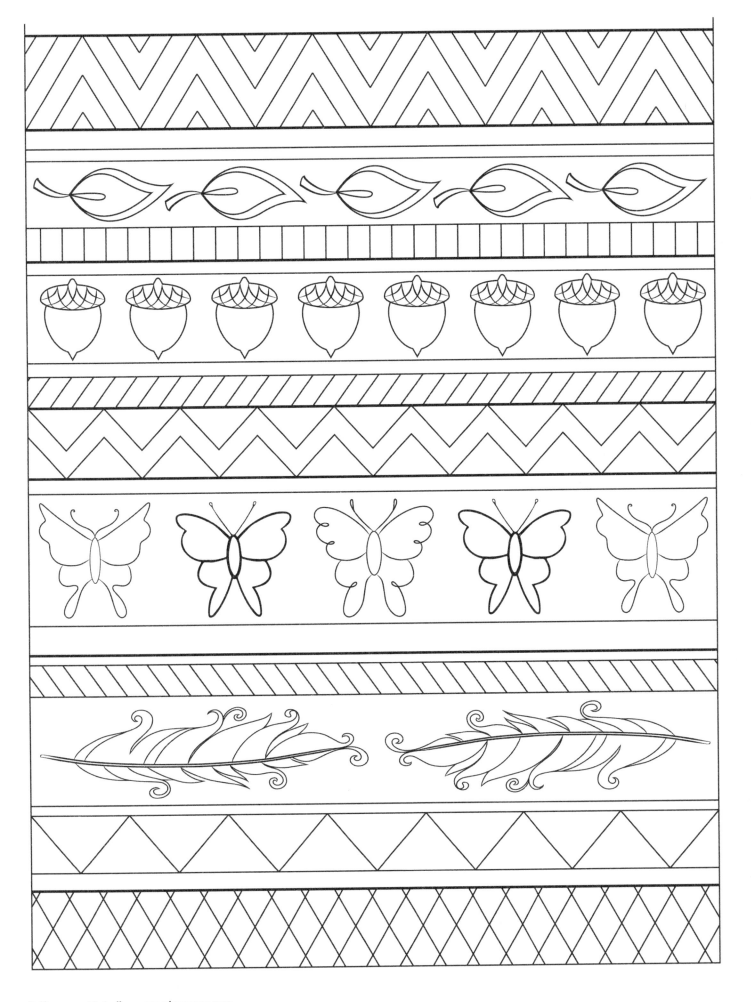

The clearest way into the Universe
is through a forest wilderness.

—John Muir

One creates oneself.

—Grace Jones

Time you enjoy wasting was not wasted.

—John Lennon

There was nowhere to go but everywhere,
so just keep on rolling under the stars.

—Jack Kerouac, *On the Road: The Original Scroll*

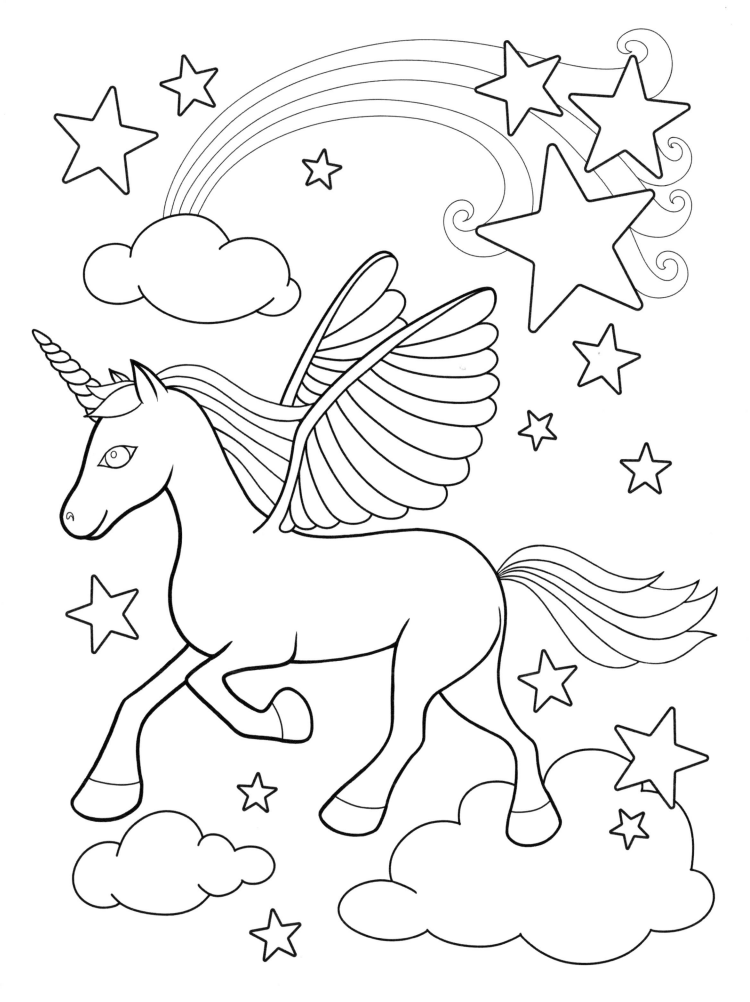

You can dance, you can jive, having the time of your life.
See that girl, watch that scene, digging the Dancing Queen.

—ABBA, *Dancing Queen*

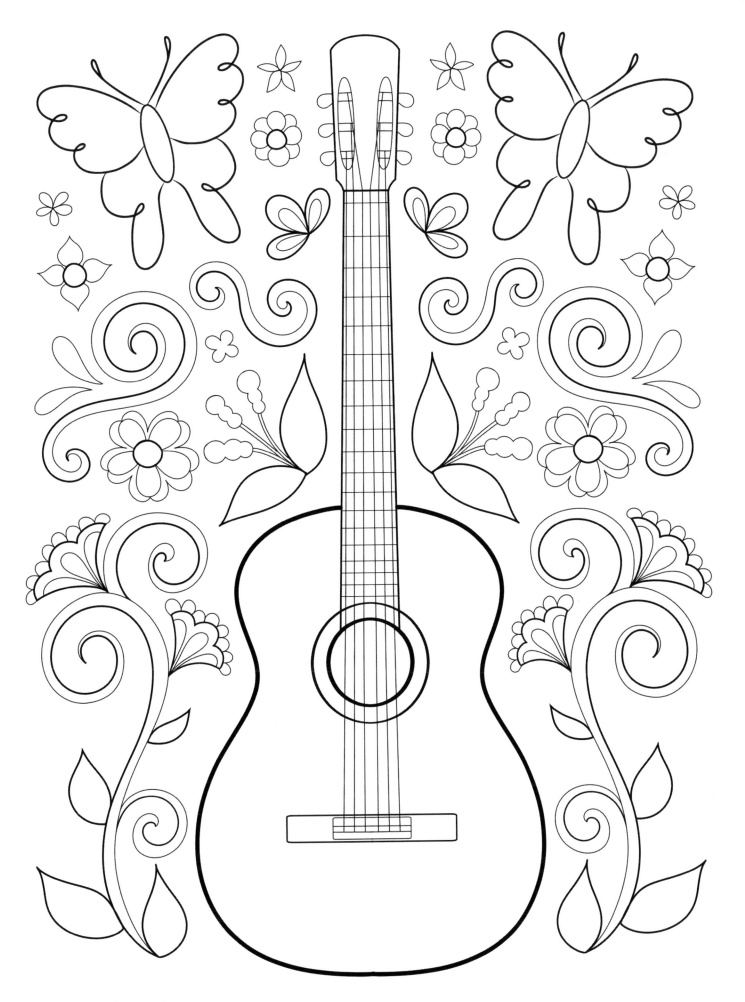

Music expresses that which cannot be put
into words and that which cannot remain silent.

—Victor Hugo

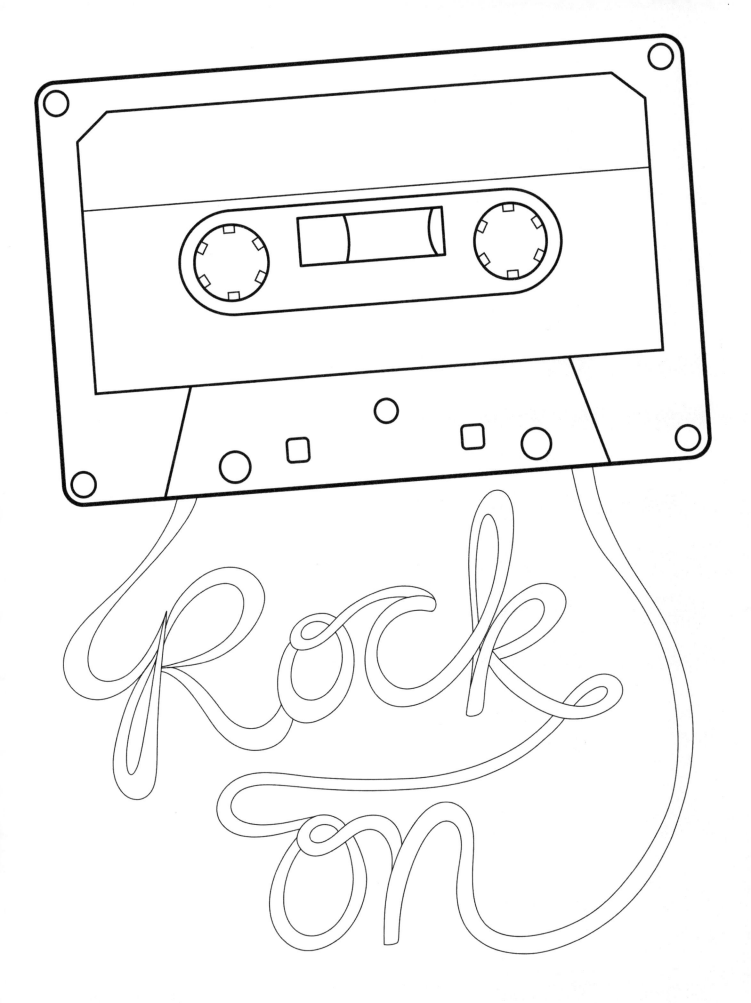

When I die, sprinkle my ashes over the '80s.

—David Lee Roth of Van Halen

Do, or do not. There is no try.

—Yoda, *Star Wars Episode V: The Empire Strikes Back*

Live, travel, adventure, bless, and don't be sorry.

—Jack Kerouac

C'mon people now
Smile on your brother
Everybody get together
Try to love one another right now

—The Youngbloods, *Get Together*

They come runnin' just as fast as they can
'cause every girl crazy 'bout a sharp dressed man.

—ZZ Top, *Sharp Dressed Man*

Video killed the radio star.
Pictures came and broke your heart.
We can't rewind we've gone too far.

—Buggles, *Video Killed the Radio Star*

For whatever we lose (like a you or a me),
It's always our self we find in the sea.

—e. e. cummings

Live by the sun, love by the moon.

—Anonymous

I am so clever that sometimes I don't understand
a single word of what I am saying.

—Oscar Wilde

I like to be a free spirit. Some don't like that,
but that's the way I am.

—Princess Diana

Work like you don't need the money.
Love like you've never been hurt.
Dance like nobody's watching.

—Satchel Paige

Spend a little more time trying to make something of yourself and a little less time trying to impress people.

—*The Breakfast Club*

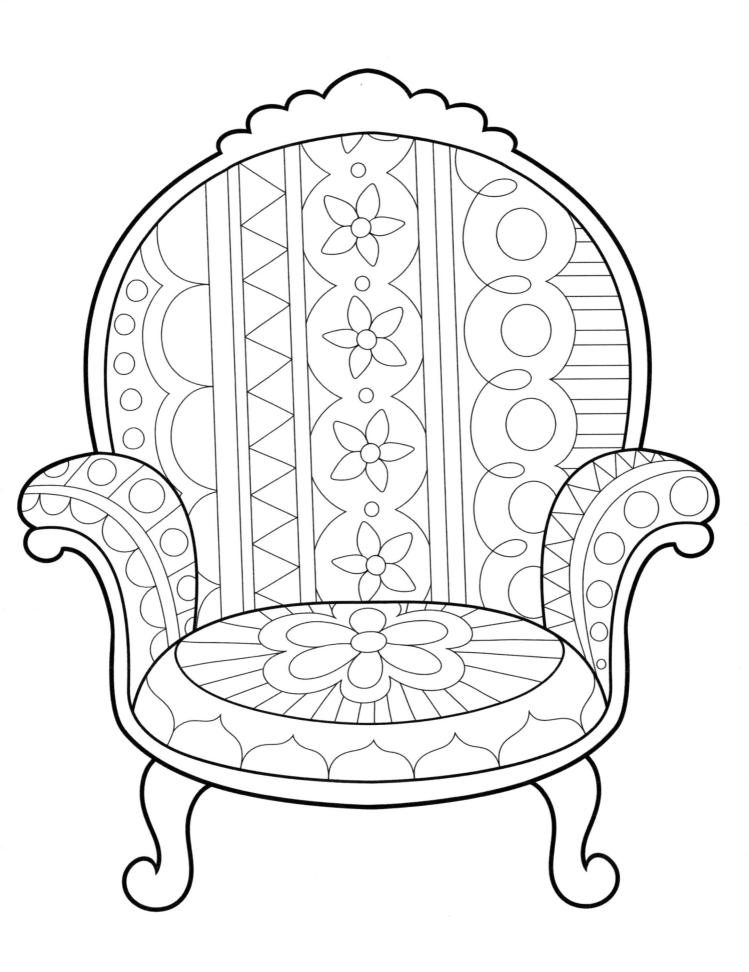

The discontented man finds no easy chair.

—Benjamin Franklin

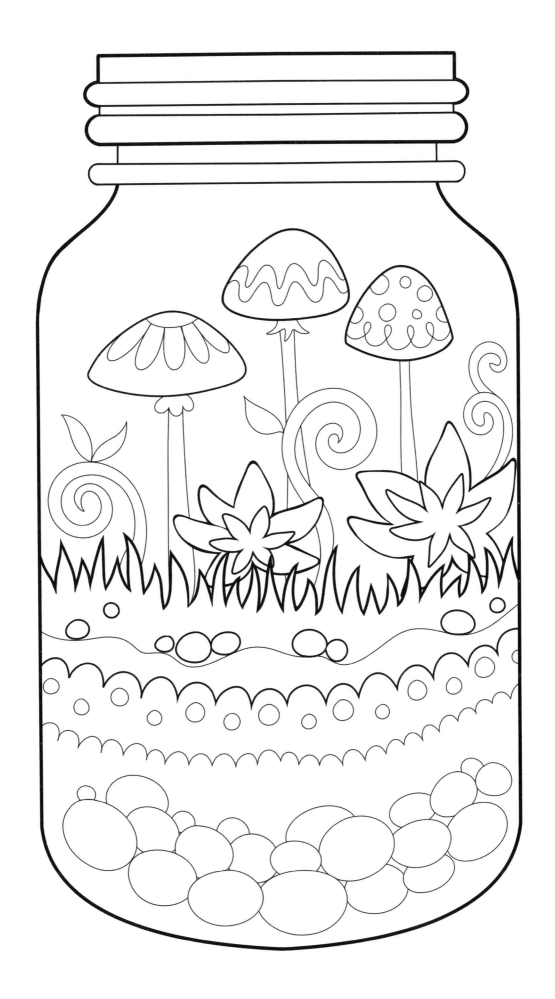

Like wildflowers, you must allow yourself to grow
in all the places people thought you never would.

—Unknown

I'd rather be hated for who I am
than loved for who I am not.

—Kurt Cobain

It is better to fail in originality that to succeed in imitation.

—Herman Melville

Life moves pretty fast.
If you don't stop and look around once in a while,
you could miss it.

—Ferris Bueller's Day Off